D1470138

THE FACE OF A WOMAN

ethan HUBBARD

THE FACE OF A WOMAN

images

from around the world

The Pilgrim Press

Cleveland, Ohio

The Pilgrim Press, Cleveland, Ohio 44115

© 1997 by Ethan Hubbard

All rights reserved. Published 1997

Printed in the United States of America on acid-free paper

02 01 00 99 98 97 5 4 3 2 1

Library of Congress Cataloging-in-Publication Data

Hubbard, Ethan, 1941 –

 The face of a woman : images from around the world / Ethan Hubbard.

 p. cm.

 ISBN 0-8298-1169-9 (cloth : alk. paper)

 1. Women—Cross-cultural studies. 2. Women—Portraits.

 I. Title.

HQ1233.H85 1997 96-49753

305.4—dc21 CIP

May all beings enjoy happiness

and the sources of happiness.

May all be free from sorrow

and the sources of sorrow.

May all never be separated from the sacred happiness

which is sorrowless.

And may all live in equanimity,

without too much attachment and too much aversion,

and live believing in the equality of all that lives.

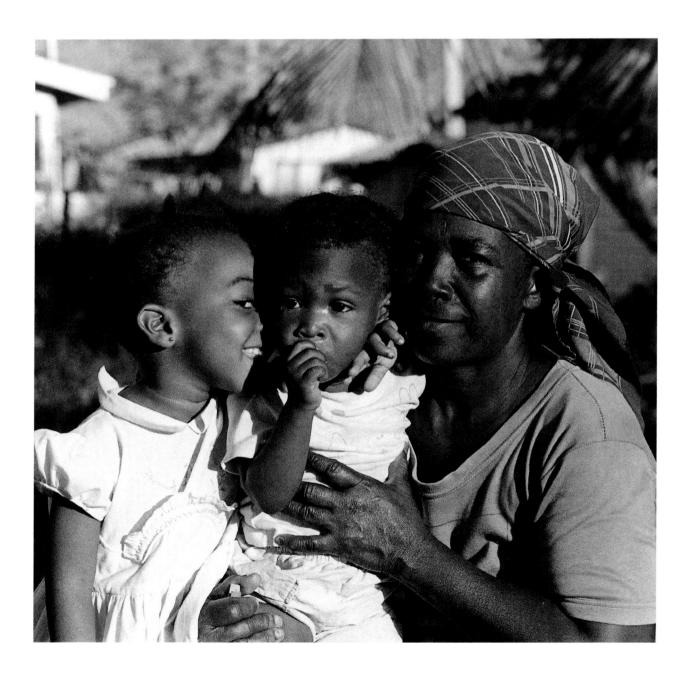

In the spring of 1978, nearing my thirty-seventh year and determined to bring a deeper sense of fulfillment into my life, I sold my land and house in northern Vermont and began spending as much time as possible with rural and indigenous people.

For the previous ten years I had worked as the deputy director of the Vermont Historical Society, collecting and preserving artifacts for the Vermont Museum and Library. Whenever I felt overwhelmed by my desk work, I would check out of the office with a couple of cameras and a tape recorder and would interview interesting Vermonters: loggers, farmers, homesteaders, and especially the elders whose life stories brought me no end of pleasure and inspiration. I realized that interviewing and photographing people was the work that I wanted to do with my life. In 1978 I left Vermont and began to travel.

My first real adventure was a two-year ramble around the United States in an old VW camper, complete with cameras and my dog Willow. Between 1978 and 1980 I drove the backroads of rural America, stopping to visit with interesting people who were leading lives very different from mine. The Native Americans especially interested me—Navajos, Apaches, Sioux, and Tohono O'odham. I traveled to their lands in my VW bus with camping gear stashed beneath the bed. I always managed to find elders who seemed happy to have me about. I would sit at their feet and ask questions from my heart, and the visits flowed from minutes into days.

It was an America I had forgotten existed—a land of wide open spaces to set my mind free, a land of tiny prairie villages with welcoming cafes, church socials, and friendly people enjoying good talk in the streets. I

shared coffee with cowboys in Wyoming, danced with Cajuns after rice harvests in Louisiana, herded cattle with Idaho schoolchildren, and brought in winter wood with Southerners and their mules.

In 1980 I began traveling farther afield: the Outer Hebrides of Scotland, Mexico's Sierra Madre, Guatemala's jungles, the mountains of Nepal, India's Ladakh region, Australia, New Zealand, Indonesia, England, Wales, Portugal, Greece, Egypt, the Caribbean, Tonga, Western Samoa, the Dominican Republic, and Canada's Arctic region.

I traveled always alone and as simply and economically as I could, with a knapsack, a tent, light cooking gear, and small gifts for people who befriended me along the way. Sewing needles, pens and pencils, balloons, and Polaroid pictures were always well received. I often brought photographs of my village in Vermont as people were often curious to see pictures of America—the blazing foliage of autumn, the deep drifted snows of winter, family farms, our village church, and snapshots of friends and neighbors.

Each country that I traveled to was alluring and interesting in its own way. The mountains and deserts, the high steppes and tundra, the islands and moors, and the rain forest jungles all awakened in me a deep sense of appreciation and fuller understanding of my own life. My senses were bathed in the sea, my mind cleared by the songs of the wind in the trees.

The different cultures proved to be empowering teachers too. Each village, each family, reflected new ways of living. The Nepalese, for example, could grow a year's supply of food on a plot of ground not much bigger than a house. The Inuit, who gave their babies away to families with none, taught me unconditional love. The Native Americans held a reverence for the natural world, Grandfather Sky and Mother Earth. The Maoris knew the joy of singing. The Australian Aborigines believed that the dream world was more real than the ordinary world. The Scots had learned to accept the weather, the Tibetans their fate. The Mexicans loved laughter and practical jokes. The Samoans believed that whoever appeared on their doorstep became family.

Coming to rest in Vermont after nearly twenty years of travel, I desired to share the faces and stories of hundreds of people who had befriended me along the way. Foremost were the gentle men and the strong women.

This is a book about strong women. Women like Mistress Susan Henry, a Caribbean native from the island of Antigua who lived in a village called Ebenezer, in St. Mary's Parish, not far from the sea. Her small clapboard house sat under shade trees close to the sere pastured hills where gaunt cattle eked out an existence.

I met her quite by chance, stepping off the tiny island bus and standing stock still at the edge of the road in dazzling noontime heat, unsure of whom or what I was actually looking for. If one were to believe in fate, I felt as if I could at that moment conjure up a family nearby whom I could come to know and love. Then I spied a house beneath the trees. I approached and called out: A woman with a strong gait came striding around the corner of the house. She was barefoot and wore a kerchief. She asked me what I wanted. I told her I was interested in getting to know and photograph some local people. Then two beautiful girls, no older than three, came scurrying out from the bushes and hid behind her skirts. She seemed to soften a little and pointed toward a bench that lay in the tree's shadows and told me to wait there.

I sat and rested quietly until six children in maroon and white uniforms came through the white picket fence with their school bags. I introduced myself to them, and they to me; we took to each other immediately. I threw a green tennis ball with which they began a game of ball tag. Mistress Susan watched from her chores. When she determined that I was not going to hurt the children, she turned and went back to her work. From that day onward, she trusted me. We became friends.

Mistress Susan Henry was, in my eyes, a very strong woman. I would sit and watch her go about her hand-washing or fire-making in the backyard and marvel at her powerful muscles breaking branches or wielding her machete or ax. She was as proficient with fire as with other tools. On damp days she could coax a fire from soggy wood by billowing her cheeks and blowing directly on the lagging coals. She cooked big meals of snapper and sea bass skinned and deboned and wrapped in banana leaves over live coals. With livestock—the ornery brown cattle and the herd of nimble fawn-colored goats—she was agile and deft as a teenager and could outfox and

out-jump any unruly animal who balked at being tethered or taken from the watering hole.

Her life was, however, not about being a shepherd, or a fisher, or a gardener, though these skills she certainly had. She heeded, above and beyond any other, the clarion call of mother and grandmother. She had no husband and the sole responsibility of rearing her three youngest children as well as her eight young grandchildren fell squarely upon her shoulders. But she never complained.

There were few other things in her life—her church, a handful of neighbors, an occasional shopping day in St. Johns with one of her grown children. But outside of these, her life was devoted to the children and their welfare. She rose at dawn with a needle and thread in her hands to mend stockings and fell asleep at evening by lamplight with the smallest child in her lap.

I often marveled at Susan's strength and dedication to raising her children and grandchildren and pondered how it had developed. I eventually came to believe that it stemmed from a difficult, hard-scrabble childhood. She had grown up economically poor at the tail end of her country's colonial period. At that time, the native Antiguans had very little gainful employment outside the sugarcane fields, harvesting the crop and burning off the old growth. At best, it was desperate, debilitating work, and dangerous too. Pay for a field worker was less than a dollar a day. Laborers like Susan toiled in the searing heat, often in noxious smoky air when the fields were burned. Wounds were endemic from machetes and machinery, and there was always the ubiquitous centipede with its poisonous bite.

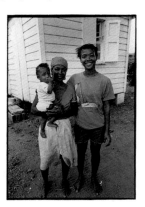

On some occasions Susan would talk about those years. She seemed to carry the scars of that deadening work to the present. Whatever actually took place in those fields was, in part, still ingrained in her present life. The fires still seemed to burn in her soul, in her sometimes fierce eyes and her seeming inability to belly-laugh. What I also sensed was her determination that her children and grandchildren would be spared such hardship. She once told me that if she only accomplished one thing in this lifetime, it would be to make sure that all her young ones had a better life than hers.

Though a straight-backed, poised, and handsome woman, Susan surprisingly lacked loquaciousness with everyone, the children included. Hers was the art of action rather than conversation. When she did speak, it was usually directed to the children to do this or that: gather the firewood, see that the rice had not boiled over, go to the store and ask Mr. Bascomb to save a handful of potatoes for the evening meal, collect eggs from underneath the house. And while she certainly could laugh, she was more prone not to. Her face, while quite beautiful, held a preponderance of tenseness and fear, as if something terrible was about to happen to one of the children. There were accidents, of course: skinned knees, a broken arm from a child falling out of a tree, a serious mouth injury to young Kenny in a cricket accident. All these and many more were adeptly seen to by Susan.

In many visits with the family, I came to see what a remarkable person Susan was as a mother, a grandmother, and provider. Her days were spent hand-washing, ironing, fetching water in buckets, gathering firewood, and cooking. She was forever mending clothes. And forever making her children respectable for school. To me, a most endearing habit she kept was that of feeding each child—one at a time—at a small table on the back porch, as if each bowl of stew or porridge was a gift outright to the child. Selflessness was what she was all about.

Women. I have watched them in a hundred circles around the world, around campfires, beneath the stars, in shady grottoes by the sea. The grandmothers, the mothers, the sisters, all giving tirelessly, giving ceaselessly to the weak and weary. I have heard their songs of comfort as they hold a wailing infant to their breast; I have seen the tears of compassion streaming down their faces as they watch a parent die; I have seen them on their hands and knees praying for the universe to bring a loved one home safely.

The women's lives portrayed here in photograph and story stand as a quiet record to loving kindness and gentleness. May these good and kindly faces continue to inspire others, as they did me. May all beings come to their own awakening. May all beings be happy. And may our beautiful planet—our home—resonate with peace and understanding till the end of time.

Ethan Hubbard
Chelsea, Vermont

THE FACE OF A WOMAN

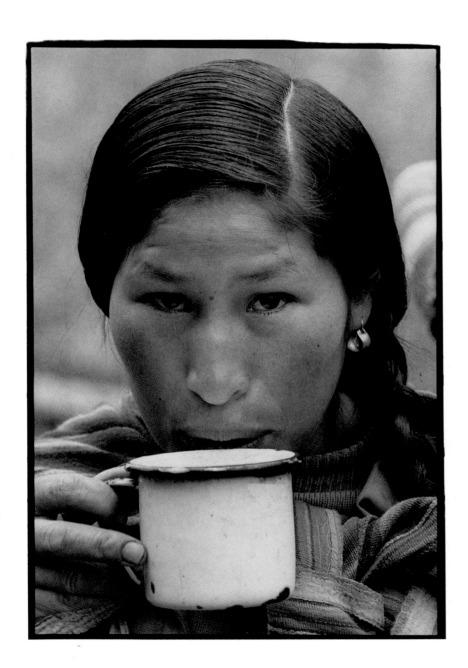

I worked in the fields with Albertina. The noon heat was oppressive at the dry winter-time of year; sweat poured off me as I tried to keep up with her. I was barefoot, as was Albertina and her two sons, and my skin was bruised and caked with earth from walking in the furrows. The small stones we cleared were easy to gather, but the large boulders demanded group effort. Albertina and I thrust our full bodies against the girth of one boulder, and her husband and the boys pulled upon it with ropes until it was dragged to the field's edge.

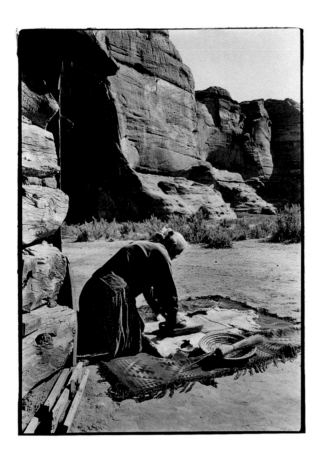

My Navajo friends, Fred and Mary Tayah, took me down into the canyon on Anasazi trails. They knew the canyon's fifty-mile labyrinth of mazes like the back of their hand, and Mary's old mother, a spare resolute herder of 83 called Bright Shining Lady, still lived there in a simple hogan. She made us Navajo fried bread and heated goat's milk over a small outdoor fire. I marveled at her physical prowess, for she still used the precarious cliff trails to come and go, narrow cuts in the thousand-foot cliffs that I dared not use.

Large storm clouds sailed over the village, light turning from orange to orange-black to blue-black. Jagged peaks blocked out the sky. The travelers along the road were Indians coming down from their surrounding communities to trade for kerosene, matches, tea, and oil.

Others returned on the trail with provisions in a cloth bag slung over their shoulders. With their short, powerful legs they overtook and passed me easily.

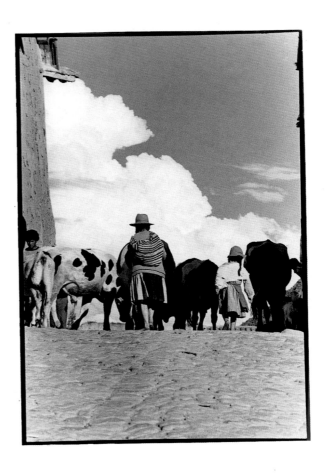

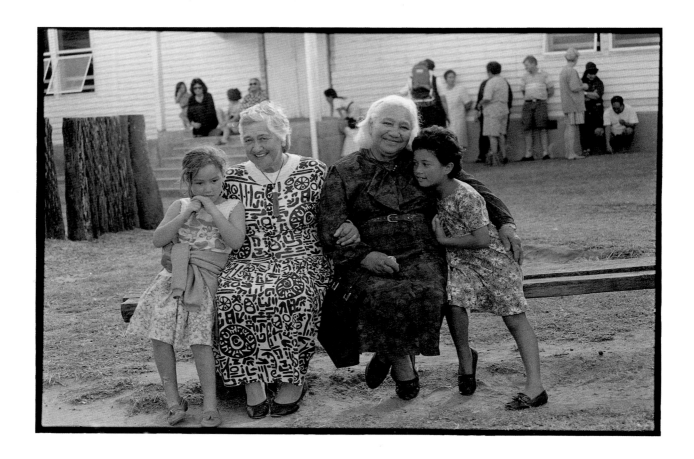

There was a celebration at the local *marae* (church), a twenty-first birthday for twins, a boy and a girl. The parents put on the feast and nearly three hundred were fed over a five-hour period. Legs of lamb, seafood, tangy sauces over poultry and beef, fruits from the bush, and sweet desserts graced long tables. In between courses the elders of the community—both women and men—gave testimonials to the importance of "right living" to the feted twins and those in attendance.

The old grand-
mother looked so
much like the
young girl. Were
they related, I
asked my inter-
preter? No, only
friends. Still, there
was that distinct
look and feel of
family. As I fol-
lowed them about
the day-long feast,
I wondered
whether the old
Tibetan ways
would persist and
whether the young
girl, so enamored
of the old woman,
would grow to
keep the old ways
alive.

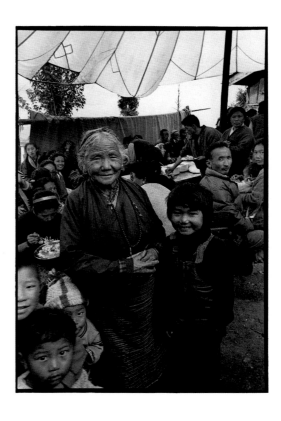

Luisa would often sit alone on a hillock. Then she would let the wind blow full in her face, and her long white hair would blow in wisps about her head. She later told me she was remembering when she had been a practicing midwife—three hundred babies delivered on these high plains, three hundred rides on horseback, often deep into the night.

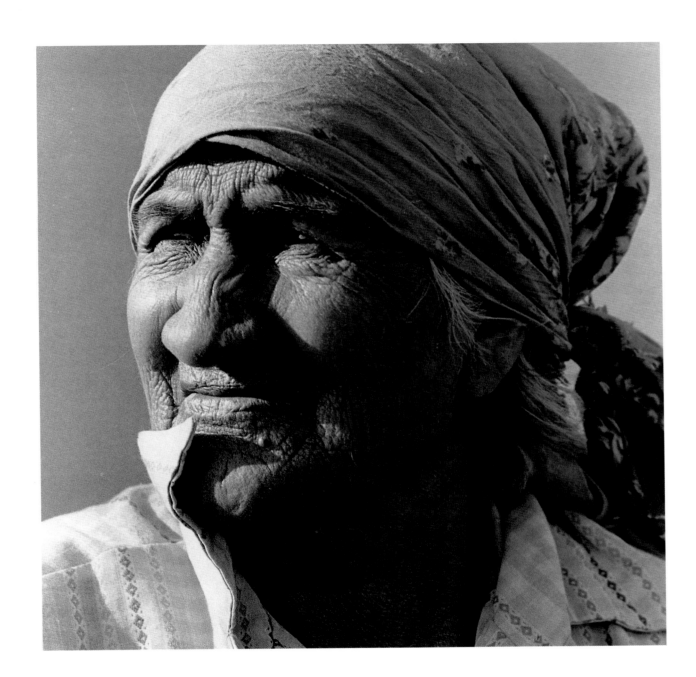

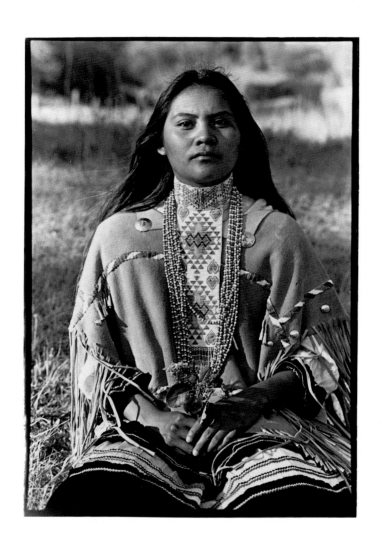

NITA QUINTERO, WHITERIVER APACHE
WHITERIVER, ARIZONA, UNITED STATES

In the tiny village of Whiteriver, Arizona, I stopped and looked up a young woman named Nita Quintero I had seen pictured in a Coming of Age Ceremony photograph in *National Geographic.*

When I found her, she was as striking and handsome in person as she was in the article. I asked her for a formal portrait, and she obliged. She sat beside the river in a dress of buckskin she had made for the ceremony.

My pony man
Makbula and I
traveled deep into
the mountains.
Winter was com-
ing on. Poplars
glowed like coals
on the slopes above
slate-blue lakes,
and fresh snow fell
on the mountains
each night. There
we met the Gujar
shepherds—
descendants of the
Gypsies—coming
down the moun-
tain passes with
their flocks of
sheep and goats.
The women were
beautiful and had
a mystic charm
about them.

GUJAR WOMAN
KASHMIR, INDIA

THE GRANDMOTHER
GAY, GEORGIA, UNITED STATES

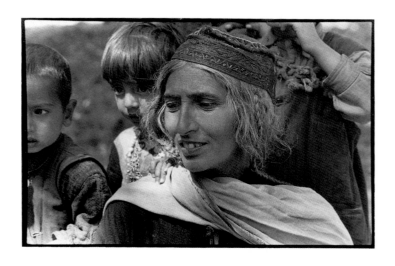

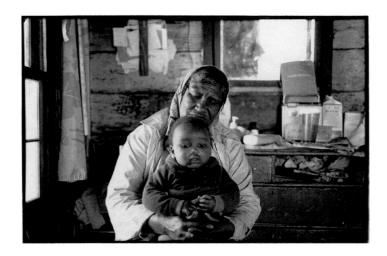

It was cold for December. There was light snow on corn stubble in the fields. My VW bus heater was on the fritz, and I had to keep scraping the inside windshield to see. I was hungry too, so I stopped at a farmhouse to buy eggs. An older woman with a child in her arms opened the door. She looked tired, but managed a smile and made me welcome. I bought the eggs, but lingered by the stove. She seemed to read my mind and pointed to a chair beside it. "Make yourself at home." Then she sat down and nodded off.

ILDA, MOTHER OF FOUR

SAN JOSÉ, PETÉN, GUATEMALA

JO BRADSHAW AND CHILDREN

ON THE COMMUNE NEAR WARKWORTH, NEW ZEALAND

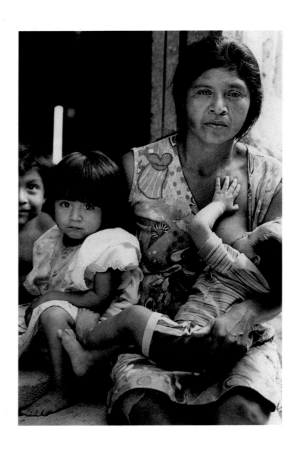

Ilda and her husband and their four small children were not Mayan, but were *mestizos* from far to the south. They were very poor and lived in an abandoned, fallen-down house far from the healing waters of the lake.

I had seen Ilda hauling fifty-pound cans of water up the steep hill on serveral occasions. That night the stars shone above the lake. We drank beer and watched shooting stars fall toward the lake.

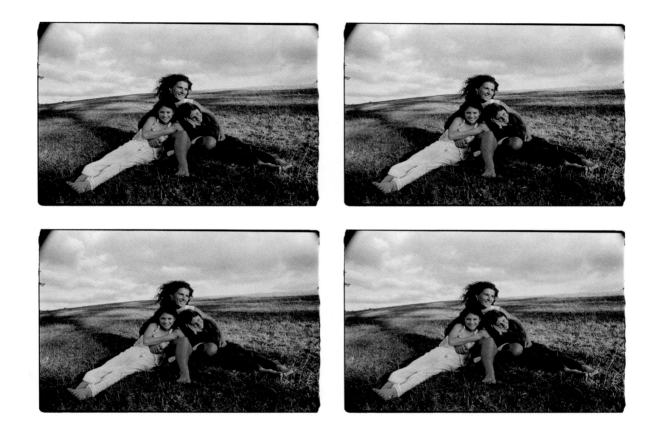

One night after harvesting two hundred bushels of organic peaches we all piled into the 1947 Dodge truck and went to the movies in Warkworth. Sharon, Dale, and Tony sat up front in the cab, and Jo and I and eight children stretched out on mattresses in the back, laughing and singing all the way into town. It was a beautiful summer night; the shadows were long and dark, and the air was soft on our skin. We drove slowly over the dirt roads from one valley into another, up steep grades and down. People waved as we went by: a farmer and his wife inspecting their garden, a small boy running down from the hills with his young cows.

A grandmother led me
over the pass today—
16,000 feet and draped
in cold mountain shad-
ows. When the sun went
behind a cloud, the
temperature plummeted
twenty degrees. She
walked like a young
girl bound for remote
Zanskar. I labored
keeping up with her.

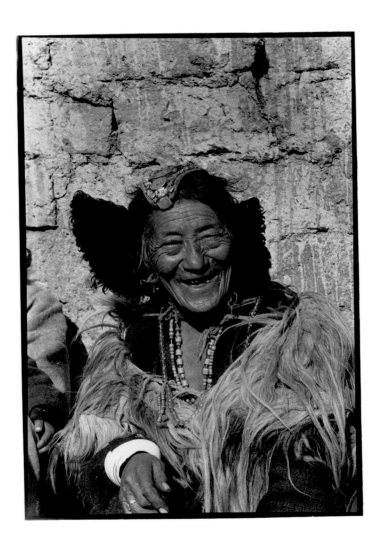

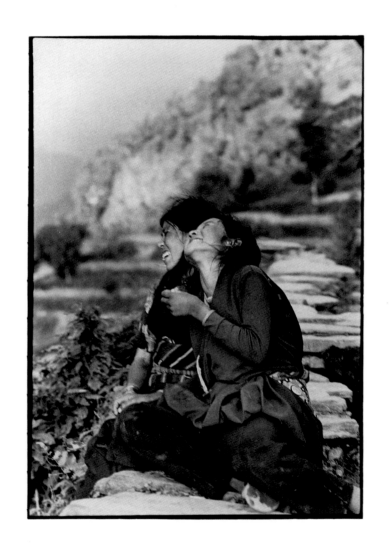

They were the first women porters we had seen on the entire trek who carried for pay. They were oddities to many,

especially the seasoned male porters who often made fun of them. It didn't seem to bother the women. They were

as strong or stronger than most of the men and were in far better shape, even with their feet bare. Sometimes they

laughed hysterically at the insults that were hurled their way.

San José is an ancient village of thatched houses on a hillside overlooking Petén Itzá, the largest lake in northern Guatemala. Most of the villagers are descendants of the pyramid builders of Mesoamerica. They grow crops of corn and beans and fish in the blue-green waters from dugout canoes. Most of the villagers still speak Mayan. In some ways San José was like any small town. But other times, when the light was just right—as I watched a woman bathing her son or paddling him in her canoe through lagoons at sunset—I was dazzled by these people, descendants of the great Maya.

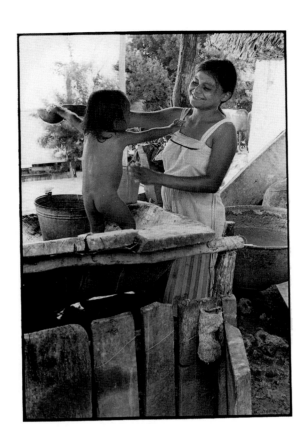

Sometimes I slipped through a hole in the ruin walls and walked to the ancient baths where the Incan maidens had once bathed in the natural springs. I laid on the soft grasses beside the stream and listened to the sound of the cascading water as it was dashed upon the smooth granite stones.

Nearby women were washing in the stream, teenage girls and women who had come down out of the mountains with packs upon their backs. They would throw down their long tresses of hair and gently scrub them with soap, then bend down on their knees to wash the frothy lather from their heads.

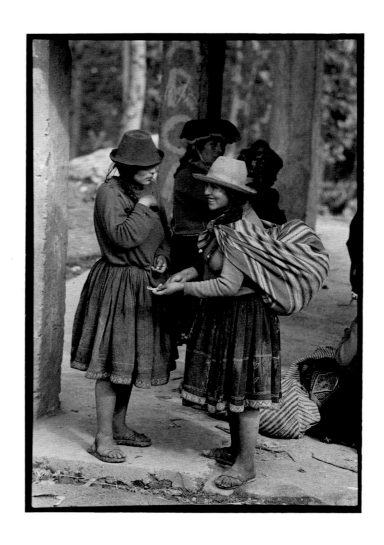

QUECHUA WOMEN
OLLANTAYTAMBO, PERU

AVOU SIU AND TAUESE
SAFUA, SAVAI'I, WESTERN SAMOA

The slow days in Samoa melted one into another, and soon a

whole month had passed. My favorite time of day was at sunset

when I got to my family's house in the jungle. Ruta would be

at her fire cooking taro and yams and Taulalei would come

down the trail with coconuts slung over his shoulders. So often

we would be silent with the ending of the day, the battered

radio softly playing island tunes, birds singing in the bush,

and chickens softly clucking. I loved hearing Avou sing songs as

she bathed Tauese, her firstborn son, in a tub of warm water.

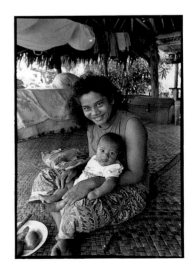

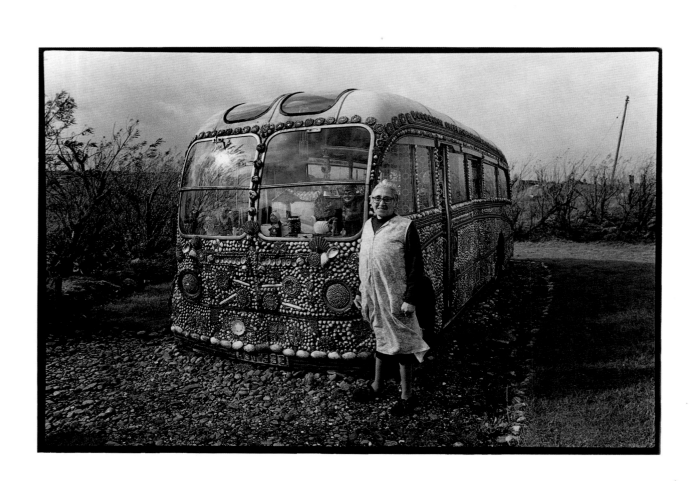

FLORA JOHNSTON AND HER SHELL BUS

OUTER HEBRIDES, SCOTLAND

Flora Johnston gave me a tour of her shell bus today. "You see, it was just sitting here rotting when I got the idea. I went to the beach for four months and collected seashells in baskets and then glued them to the bus. And inside I made a seashell museum, everything made of seashells. From the tours I give I can collect nearly two hundred pounds a year. I give the money to the Multiple Sclerosis Foundation of Glasgow, as that's the disease from which my husband died."

ELLEN GAWLER, REMEMBERING THE BORDER CROSSING

BELGRADE, MAINE, UNITED STATES

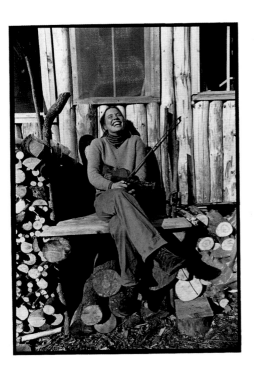

Ellen had been traveling in Canada with a busload of San Francisco street musicians, mimes, and jugglers. They were a jolly bunch back in the early 1970s with their tie-dyed clothes, puppets, and political satire. Once, she said, they were stopped at the U.S. border when coming down to Seattle.

"Well, that grumpy old border crossing guard didn't like the looks of us. We were counterculture. Our painted bus and merry musicians must have threatened him. So he ordered us to march in an orderly manner across the border while they inspected the bus. Guess what? We didn't just walk single file.

We strutted, we jived, we boogied our way across that line with our slide trombones and tambourines and goofy hats and painted faces. Heck, why walk somber when you can have a parade."

FULJENSIA TESECUN

SAN JOSÉ, PETÉN, GUATEMALA

QUECHUA WOMAN

HUILLOC, PERU

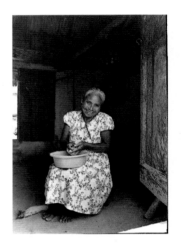
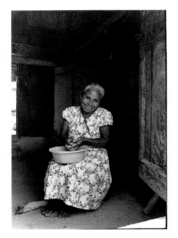
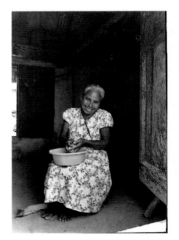
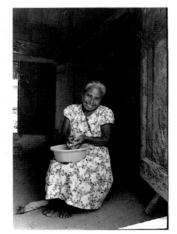

I began to learn Mayan. My teacher was a neighbor, Fuljensia, wife to Francisco. They lived in a thatched hut in a thicket of trees and spoke Mayan among themselves. "Te ee yos (how are you)?" she would call out to me as I approached on the path. "Bee sha bel (I am fine)," I would respond. I had practiced in front of a mirror for ten minutes. When I couldn't remember other words she had taught me, I would sneak a look down at my hands, where I had inked them onto my palms. If the children saw me doing this, they howled with delight.

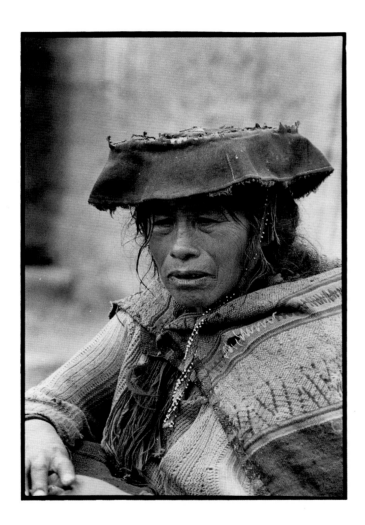

I came upon an Indian celebration in the mountains at close to 12,000 feet elevation. I was walking along a trail when six women approached me laughing and greeted me with *"Allinllanchu* (how are you)?" One of the women with a red poncho and a pancake hat took ocher from a bag about her waist and smeared my face with six or seven long lines, initiating me into carnival.

IN THE FOREST

UNION ISLAND, ST. VINCENT AND THE GRENADINES

So many of the older people
of Union Island sat alone
for long hours under shade
trees in pensive moods.
I never knew what they
were thinking. Perhaps it
was about the old times,
their ancestors, a slower
pace, a richer time.
Did they see their mothers
cooking on an open fire
beside the hut? Did they
hear their fathers
calling other fishermen to
haul in the nets? Or did
the lovely quadrille dance
still linger in their hearts,
the sound of fiddle and
guitar and drum?

Each night I frequented the eleventh-century church. It was a good place to pray and to

give thanks for the blessings of the day. Inevitably there would be an old woman

in black upon her knees before the altar. One night she prayed upon the cold stone floor

without respite for nearly forty-five minutes.

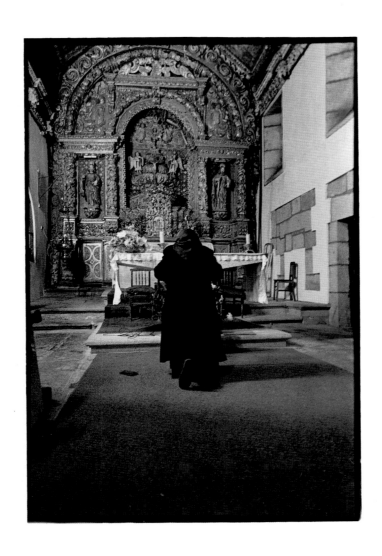

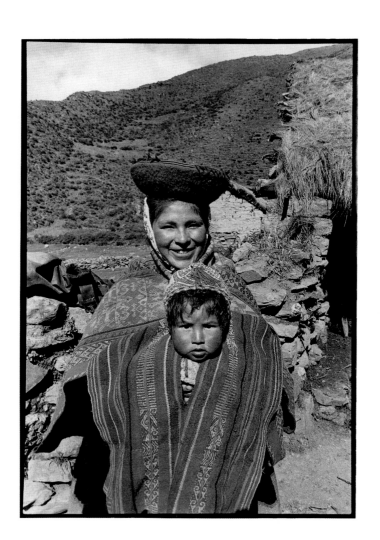

Simeona ground dried beans on a stone slab with quick dexterous motions of her strong hands.

Then she blew through a metal pipe onto smoky twigs to bring oxygen to the fire. She rose up and hesitatingly asked me in rough Spanish if I would be the godparent to their younger boy, a one-year-old they called Tomas, someone I didn't even know existed. She smiled and pointed through the smoky darkness to their bed. I walked across and adjusted my eyes to the light, beholding a fat, brown face with a head of profuse black curly locks. Small black hands reached through the darkness and pulled at my cheeks. He cooed like a dove upon seeing me, and I adored him.

Miss Lucy was a single woman ranching on her father's old cattle station out at Euralia. She and her sister Miss

Harriet kept sheep and cattle on 35,000 acres in the outback, without electricity, telephone, or automobile, much

the way their parents had. The Shephard sisters wore smocks and sunbonnets, muslin stockings with holes in them,

and hightop basketball sneakers. They had but one modern convenience, a three-wheel motorcycle with which to

gather up the bulls at dusk. One night I saw Miss Lucy wheeling about on it like a race car driver. Six red kelpie

dogs hung over her shoulders enjoying the ride.

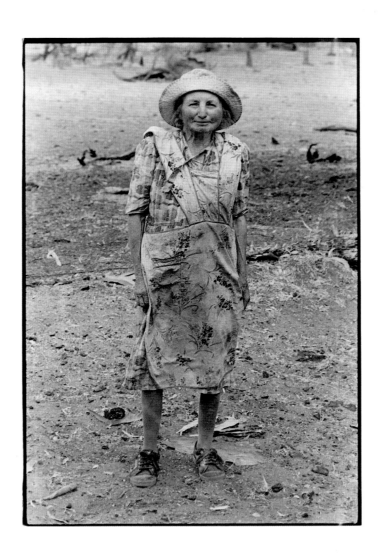

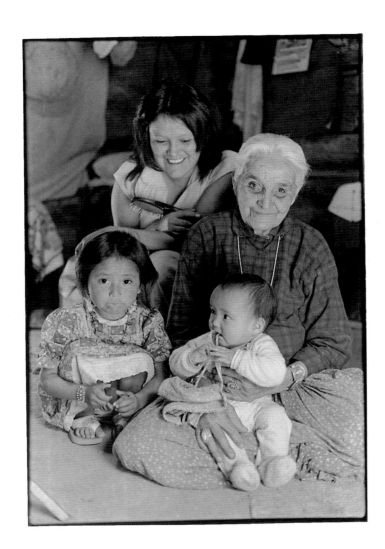

At dusk, when the
canyon was bathed
in an orange light,
Bright Shining
Lady trailed her
sheep and goats
along the ancient
pathways, her
Navajo herding
songs echoing off
the red rock walls
and floating up
out of the canyon
like prayers.

MISS HARRIET SHEPHARD
ORROROO, AUSTRALIA

QUECHUA FRIENDS
OLLANTAYTAMBO, PERU

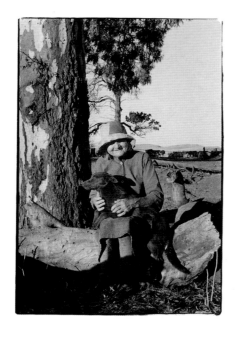

My favorite time to visit with Miss Harriet and her sister Miss Lucy was

in the late afternoon when they trudged out into the hills to find their

cattle. It was my job to open and close the final gate, a job that gave

me time to lie on the warm red earth and watch rosy-breasted parrots

and gallahs bathing in the mossy water tubs. Soon I heard the sisters'

hoots and hollers and the yelping of their thirteen red kelpie dogs and

saw a great procession of bellowing cattle driven forward by the two

women, clouds of red dust billowing above them.

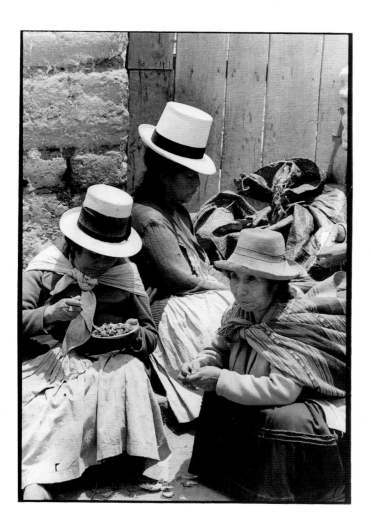

They would serve tamales and warm punch to the drivers of huge cargo trucks lumbering down from the mountains. The women sat long, patient hours in the chilly night air, hopeful of a sale or two. I often sat with them in their vigil. When a truck did stop, the women ran over with their wicker baskets of food, their plaintive voices rising in the night, *"Plátanos, plátanos . . . choclo, choclo . . . comprame por favor, comprame* (buy from me, please buy from me)."

I met an old woman while wandering the steep hillsides of olive trees south of town.

She was leading a white goat with curved horns that shone in the soft light of autumn's

afternoon. My one-hundred-word Greek vocabulary enabled me to comprehend that she

had been born in Turkey, had never married, and now supported herself by making goat

cheese twice a week—and that she was happy.

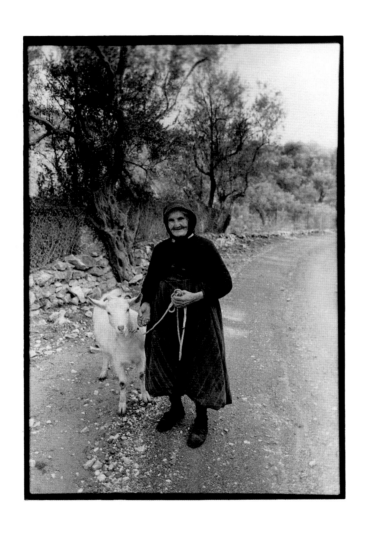

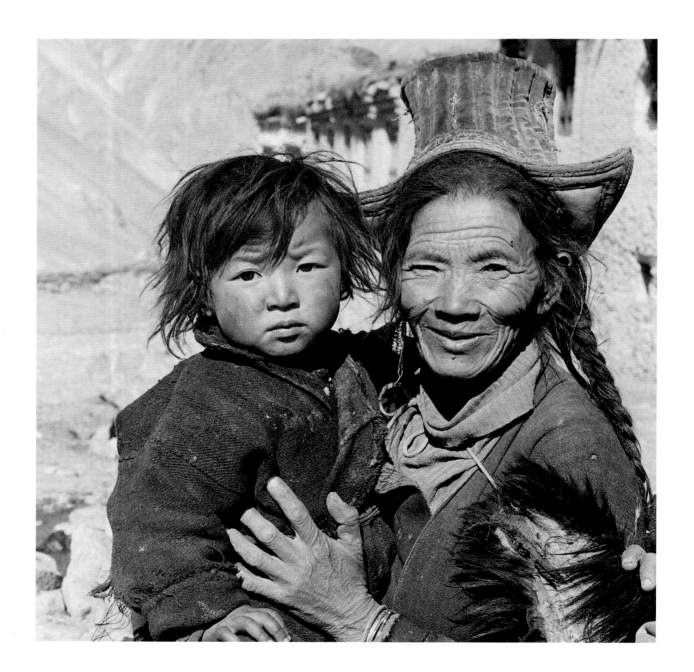

In a town named Hankar, we passed villagers dressed in traditional costumes harvesting food.

I lay down at the edge of the field and slept in the warm autumn sunshine.

I was awakened by a woman and her child who had come with a handful of peas.

We sat together for a time, shelling peas, the child staring at me with wide eyes.

THE WOOD GATHERER

ABOUT TO HITCH UP HER DONKEY, ANTIGUA

ZOAMILLA SILVA

SAN MIGUEL DE ALLENDE, MEXICO

RAKING HER YARD

HA'ANO, HA'APAI, TONGA

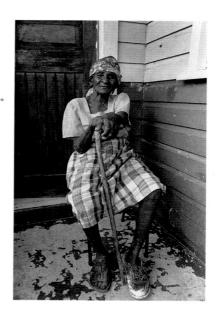
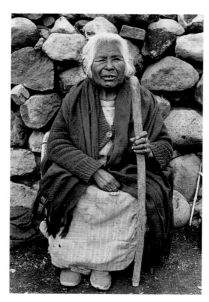
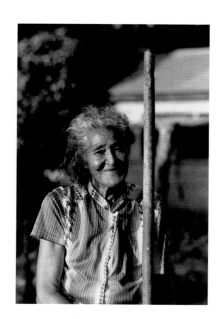

An old wood-gathering woman near Buckleys Village jumped astride her thin white donkey with a machete at her hip and rode to the mountains.

One afternoon, seeing an old couple in their eighties struggle in the heat, I gave them a ride home. When I asked Zoamilla where their house was, she pointed to the base of some trees at the outskirts of town. All I saw was a charred fire pit, a tarp, a box of clothing, an overstuffed red chair with springs hanging out, and some pots and pans. When I asked her again where their house was, she simply said, *"La tierra esta nuestra casa* (the earth is our home)." Zoamilla and her husband lived on the ground.

A billowing wind buffeted the village Sunday. No one was about. I wandered through the jungle gardens and along the village pathways where I came upon an old woman sweeping her dooryard clean of leaves that had fallen in the night.

Marguerite Lamb often stood by the window and watched life go by on a slow day. She would watch the young hippies come into town with bare feet and ripped jeans, a sheep or goat or a bunch of kids in the back of their pick-ups. And then there were the native Vermonters who she had gone to school with and whose fathers and mothers she had known. All passed before her and she was gracious and kind to them all.

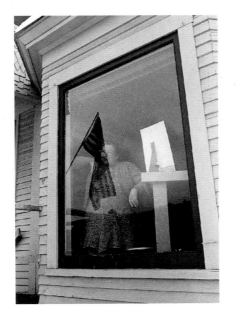
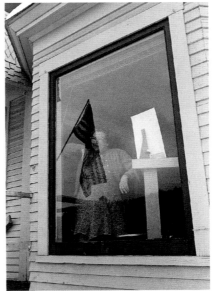
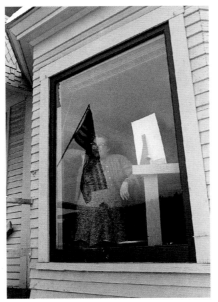
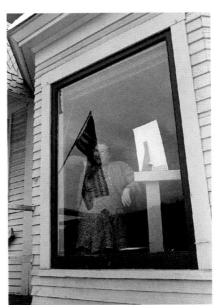

AT THE GRIST MILL
MARKA, LADAKH, INDIA

My guide and I walked slowly through the mountains, taking time when the spirit moved us to

work with the villagers harvesting grain and rice. In a mountain village called Marka we

spent two days helping a woman who kept a grist mill. I'm not sure whether I was a help or a

hindrance, as the horses there were spooked by my smell, and the women who brought in their

grain to be milled spent more time twittering and staring at me than they did at their own work.

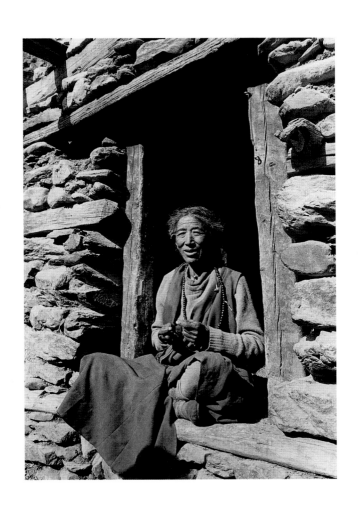

GURUNG WITH DROP SPINDLE

MANANG, NEPAL

MRS. DESCHINI

MANY FARMS, ARIZONA, UNITED STATES

In Manang my Sherpa Kipa and I stayed on a rooftop that belonged to an old woman who reminded me so much of the Native Americans I knew—their high cheekbones, the tonal quality of their languages, and even how they spun wool on a drop spindle.

The old grandmother served me dinner by the fire: stew with yak meat, Tibetan bread, and strong salt tea with rancid yak butter.

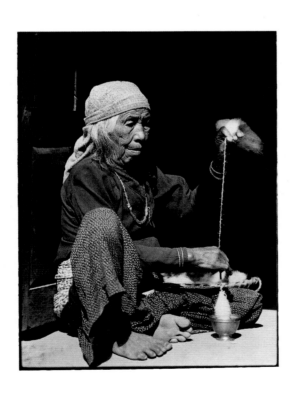

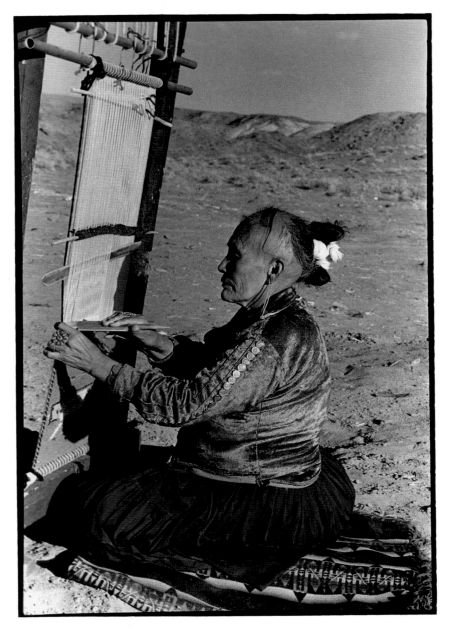

I soon began spending time with the Deschinis at their small farm in the desert. I enjoyed coming in the late afternoon when the desert shadows were long and purple. Often Mrs. Deschini, a tall, lithe woman with a beatific smile, wove on her loom in the dooryard. A grandchild would often sit beside her, watching as she created the designs of her people.

She was an anomaly to her village. She and her four small children would winter alone in the high mountains. All the other households had already moved down to the lowlands for the winter months. And this—her fourth winter alone there—would be done without a husband. I had met her by chance while crossing her potato fields. She had been friendly and had invited me to their hut to share a cauldron of scalded goat's milk and to warm myself by the fire.

Mistress Olive Clauden made me breakfast this morning at her little outdoor kitchen—painted pastel green and sea blue. She gave me fresh eggs and rice and fish and strong coffee with wild chicory. She and I talked about island history for nearly an hour.

"Some people hanker for the city lights, but not Ray and me. We like barn lights. Nothing finer than to see those lights beckoning to us for chores and our cows."

GADHI SHEPHERD

NEAR DHARMSALA, INDIA

OLIVE CLAUDEN

UNION ISLAND, ST. VINCENT AND THE GRENADINES

ANN BURKE

BERLIN, VERMONT, UNITED STATES

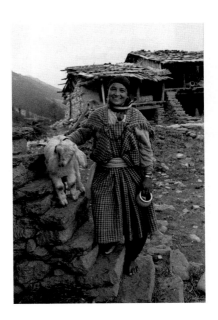
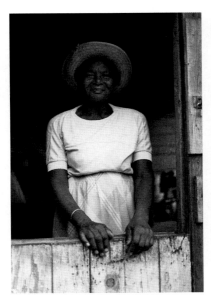
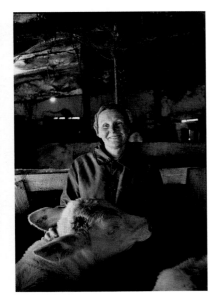

GUJAR WOMAN

KASHMIR, INDIA

LEONELDA

DAJABÓN, THE DOMINICAN REPUBLIC

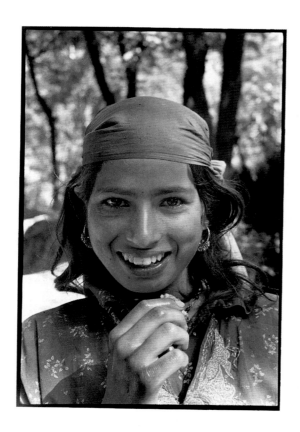

A Gujar woman
coming out of the
mountains with her
sheep and goats
once again made
me assess my own
mind, my own
motivations. She
invited me to share
mint tea with her
mother and father,
and all the while
as she tended the
fire I marveled at
her joy. She
seemed to skip and
sing with every
breath.

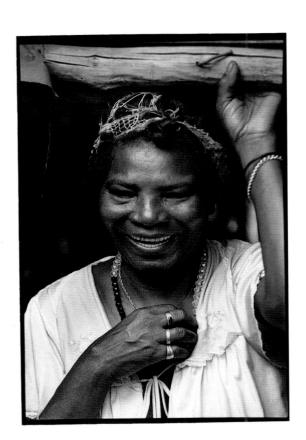

the struggle of
subsistence
farming, the lack
of even a single
luxury, and
absolutely no
money—she had
so much. Her
smile said a thou-
sand words.

The simple joy she
possessed from
merely being alive
staggered me.
With so little—a
house made of
sticks and boards
and tin with an
earthen floor,

Flo tended the kitchen stove with a proud determination on cold April mornings in an effort to warm the

near-dead lambs that Joe brought her in his arms. It was exhausting work. Still, she kept her softness and

gentle sense of humor and tried to keep up with the oncoming flood of young ones. "They're coming in

wholesale," she exclaimed with a slight smile on her face.

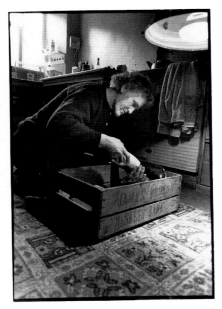
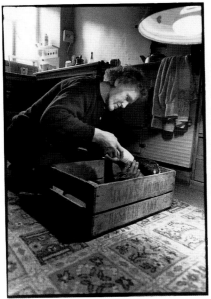
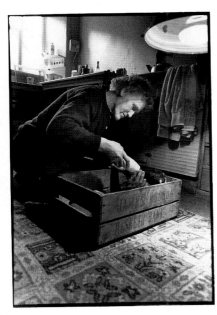

My friend Sharif and his wife Saba had a fine garden that they let me use when I was tired and needed refuge. I would enter it as I would a cathedral, with some particular need for sanctuary and silence. The green filtered light made dappled by a thousand hanging fronds of date palms was cool. Saba would make tea for Sharif and me, and we three would sit on flat rocks and talk freely. I always found Saba refreshing, for she chose not to wear the veil and was a free-thinking individual who spoke graciously to me, a stranger in the oasis.

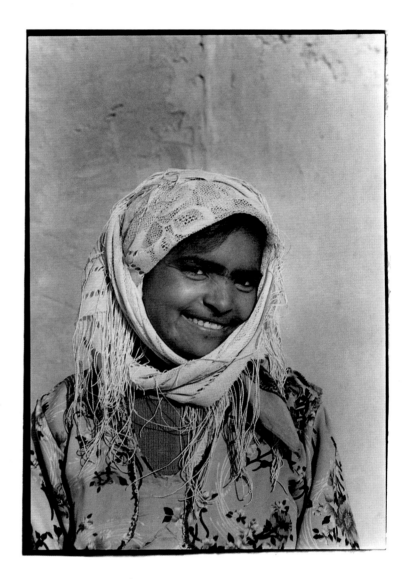

SABA, IN THE OASIS

FARAFRA, EGYPT

SISTER ANNA WITH MAYAN GIRL

SAN JOSÉ, PETÉN, GUATEMALA

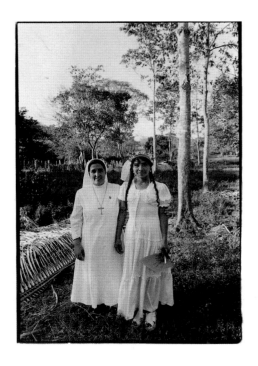

Sister Anna, a Catholic nun, gave first communion to a Mayan Indian girl. It was a bold thing to do.

She had been warned by both sides—the repressive Guatemalan government and the stir-crazy

rebels with their machine guns—that bettering the lot of Indians was taboo.

Still Sister Anna went about her daily life with great confidence and immense joy. She told me that

her love for the sacraments of Jesus Christ far outweighed any threats to her own safety.

Deirdre Beckwith

Craftsbury, Vermont, United States

Her name was Deirdre, but in my mind she was "Sister Golden Hair." When I first met her, she was going to an alternative high school in Vermont, studying draft horse management and sustainable organic farming. She told me then that one day she was going to have a team of horses to pull a home-on-wheels—and travel. One day in the mail I got a picture of Deirdre riding on a cart pulled by three young Belgian mares.

Klutilde

Moimenta, Portugal

In the north of Portugal I took a house in a remote two-thousand-year-old village called Moimenta. The village lies nestled in a plain only three kilometers from Spain, close up against the rugged mountains. The province is called Trás os Montes, the Land Behind the Mountains. It is a wild and primeval part of the world, where wolves prowl at night and Gypsies still come to town on donkeys.

Mistress Margaret Ovid

Union Island, St. Vincent and the Grenadines

I came upon an old woman shelling wild chicory for her morning coffee. She sat upon a bench with her legs straight out before her. We talked for nearly an hour. When I asked her if she was still strong and could get around at 87, she jumped up off the bench, took me in her arms, and began dancing with me in a wild quadrille dance step. We both laughed. "Now you tell me if I'm strong," she said as she whisked me about with strong arms.

Teresa

Dajabón, The Dominican Republic

Upward four teams of surging oxen plowed. Hillsides of red earth and mountain terraces of loam were turned over in autumnal heat. Men grappled with the plows while strong women ran after the teams to haul away the massive upturned stones. When work halted, I moved closer and visited with a woman named Teresa as she rested in the shade of a fallen-down house.

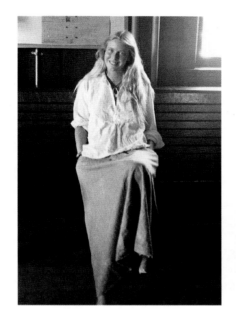
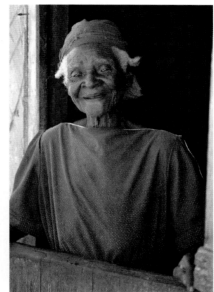
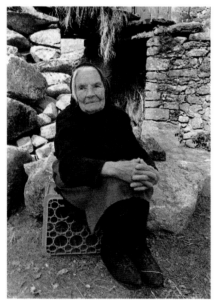
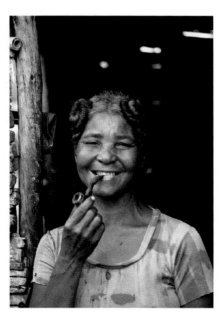

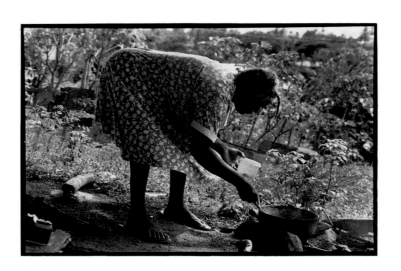

Miss Jilima was a Grenadian who was visiting her cousin, Miss Ester James, on Union Island.

I stopped on my way to the mountain and found Miss Jilima making a local dish called chili beebee.

Miss Jilima parched the corn in a pan over an outside fire until it was savory, and then ground

the golden kernels in a hand grinder to produce a delicious powder. It seemed important for her to take the

long hours to make the food. I suspected that it was a family tradition.

At a picnic on the tundra an old Inuit woman with a wrinkled face and eyes that twinkled stood up.
She bent down and picked up a mussel shell and asked her family if they knew what it was.
She then proceeded to explain that the shell had a function in life, and that each member of the family
also had a purpose, a mission. The shell served as an introduction to a creation myth about
how the animals and the ancient people had come to the land of ice and snow. The small children gazed
up in wonder as she spoke.

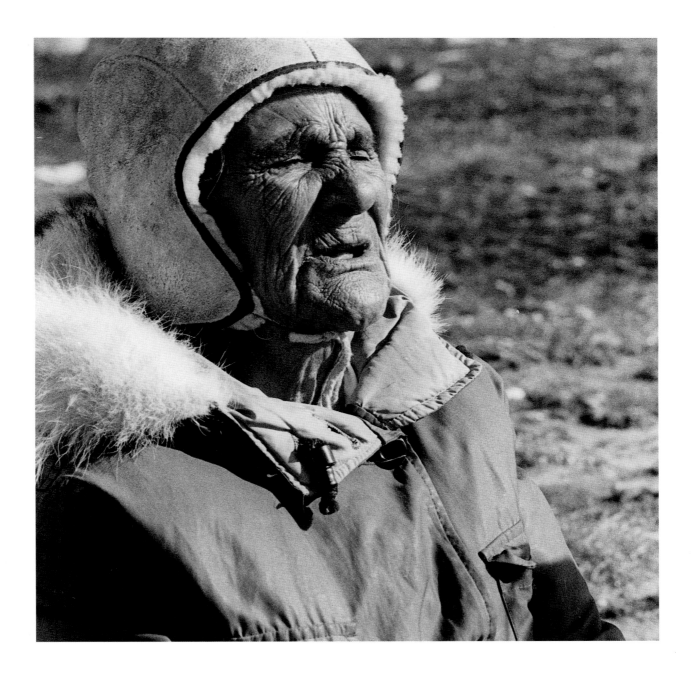

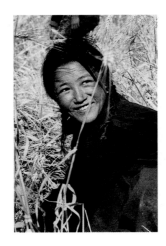

My pony man Tsetan and I arrived at a small settlement in the afternoon when the women were cutting barley in the fields. A deep cold descended on the valley and the villagers welcomed us into their homes. We stayed with a woman and her husband who seemed intent on showing us their meditation hall on the second floor. It was a formal room: embroidered cushions on a red lacquered floor, tapestries and *thangkas* on the walls, bells, chimes, statues, prayer flags, and a fine library of clothbound Tibetan Buddhist volumes. Wintertime, she explained, was the season when the people poured themselves into their devotional practice.

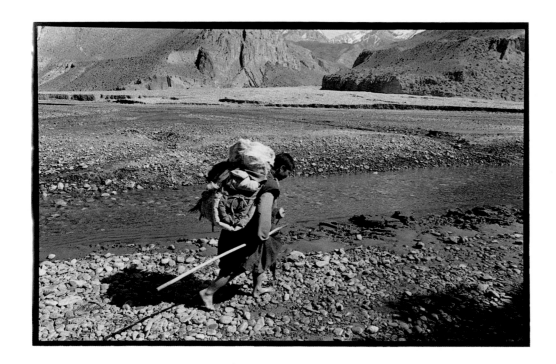

All day I watched her walk along the sere Kali Gandaki riverbed with her walking staff and gear strapped to her

back. She was alone and barefoot. Nearing afternoon, I summoned up my courage and overcame her to ask if she

would like to have tea and oranges and biscuits with me. She nodded her head and we both collected dried yak

dung and made a small fire upon which to boil our tea water. When I asked her where she was bound, she told me

to a monastery in Kathmandu for a three-year retreat.

With her daughter serving as interpreter, I asked Louisa how and when she and her husband had come to live in Whale Cove. Louisa responded with a long story about the Keewatin Eskimo people being on the brink of starvation in the 1940s and 1950s and being unable to live as nomadic hunters because of the dwindling number of game. In the early 1960s, she explained, the Canadian government relocated the people to Whale Cove to fish and hunt whales. She and her husband, Leo, had made the long haul of 250 miles by dogsled, transporting themselves and their four children and all that they owned.

LOUISA, YOUNG LOUISA, AND BABY, INUIT
WHALE COVE, NORTHWEST TERRITORIES, CANADA

ANI PALO, AMA, AND CHILDREN
GANTOK, SIKKIM, INDIA

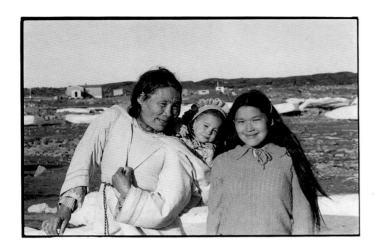

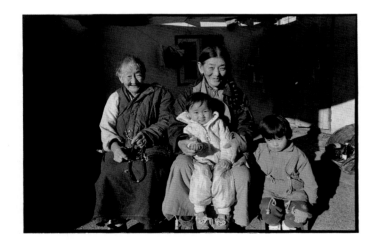

As Tibetans fled genocide at the hands of the Chinese army, families fled their homeland on foot, a long, nightmarish journey. Six members of Ani Palo's family died prior to or during the long march to India. When the survivors arrived in a weakened condition in Sikkim, Ani Palo and her niece Ama took what work was available: mixing boiled tar and asphalt in flaming cauldrons along the roadsides to repair the surfaces. The noxious fumes and the searing heat punished their lungs, but they stayed with it and saved their money and made a good home for themselves and a growing family.

It was thirty-eight below zero along the Canadian border. I stopped and visited with an old friend, Erdine Gonyaw. She was busy at work in her farmhouse making pies for "town meeting" in her old woodburning stove. Though slated for the event the next day at the town hall, we had a midmorning snack of apple pie and hot coffee. She said she could justify it because of the sub-zero temperatures. We both laughed and savored the treat.

ERDINE GONYAW
ALBANY, VERMONT, UNITED STATES

CHER ON THE ROAD
COTTONWOOD, ARIZONA, UNITED STATES

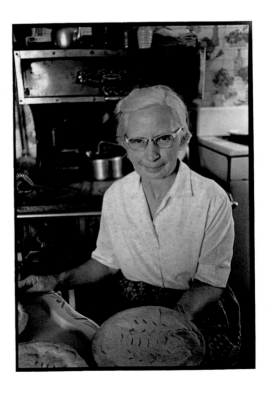

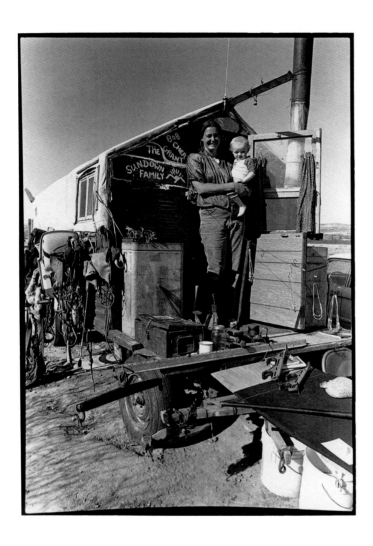

Driving to Jerome on backroads I came upon two wagons, three donkeys, one miniature mule, and a small horse resting alongside the road. Sleeping in the grass nearby was a young woman, her cowboy husband, and their young son. It was the Sundown family. The woman, named Cher, told me over coffee that she had been born an Army brat and that somewhere in her youth she decided that she was going to have an extraordinary life. She married Bob Sundown, a cowboy and ex-rodeo clown, who promised to take her around the West in a covered wagon. They had just completed 3,500 miles when I met them.

*My pony man Tsetan
and I stayed two
nights at 16,000
feet in shepherds'
huts—crude cham-
bers with three-foot-
thick stone walls.
A poor shepherd
family from the
lowlands were the
last people out in
the mountains
with their herds at
this late season.
The mother wore
skins and milked
yaks and sang low
moaning chants
as she worked.
At dawn when
we packed to leave
she filled our
flasks with strong
Tibetan tea.*

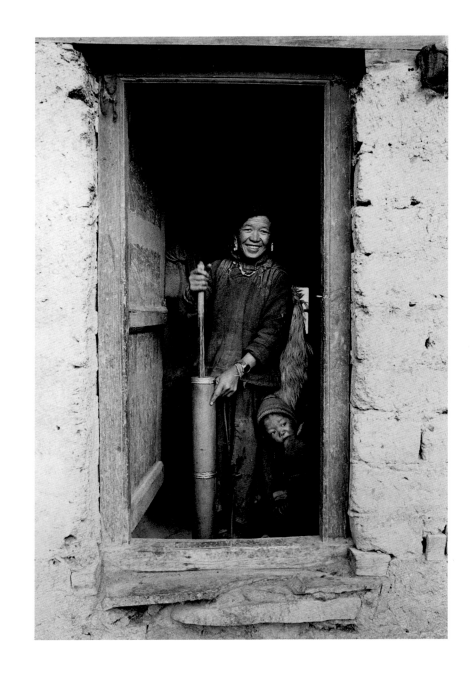

MAKING SALT TEA

LADAKH, INDIA

TARAHUMARA WOMAN IN CAVE

ESTACION CREEL, MEXICO

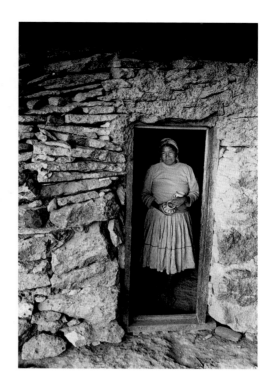

I came here to see the Tarahumara Indians, who live in caves and stone huts in the high back country of the Sierra Madre. Perhaps the most traditional indigenous group of Native Americans between the Arctic Circle and the Amazon, they are a large group—forty thousand or more—who live on one of the most demanding landscapes of the North American continent. They work tiny plots of stony land, growing corn and beans at staggering elevations—12,000 and 13,000 feet. In contrast, they herd sheep at the bottom of Barranca de Cobre, the deepest canyon in the world. They eat rattlesnakes and wolves, eels and lizards, roots and berries, and rarely descend into the villages of the white man's world. The Mexicans call them Cimarones (the wild ones). The white men call them Tarahumaras. But they prefer to call themselves Raramuri (the runners), because most young adults can run upward of a hundred miles without respite.

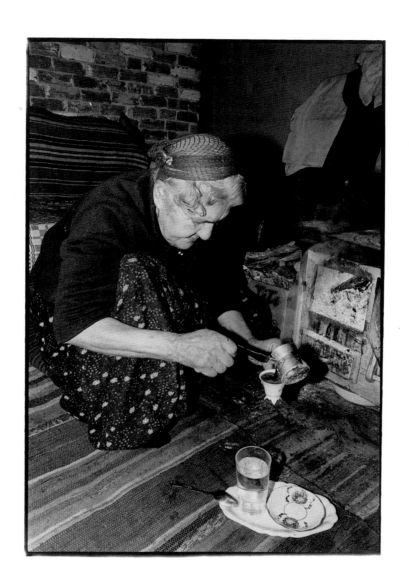

I lived a full month in Heleni's cold garret room, picking olives with the men of the village and never ceasing to love

Heleni. On those cold December days in the mountains, I liked to lie on Heleni's floor on the yellow cushion, the

one that was embroidered and always felt like a friend under my neck. Heleni hovered beside me, opening the tiny

stove door and whispering, *"Ella koudo, ella koudo, katzi, katzi* (come lie down)." She made me strong Greek cof-

fee as was her custom, muttering to herself in Greek and slyly kicking the dogs from out beneath her bare feet. She

touched my forehead as I lay sick by the stove, and in that single gesture was the touch and the feelings of a hun-

dred emotions. I loved her immensely.

I passed by small settlements of twenty and thirty houses where women congregated for market day. I peered

into the barnyards as I walked by, catching glimpses of burros swishing their tails and small bare-bottomed

children playing in the sand with a stick and some stones. Old grandfathers chopped wood, teenage girls with

towels around their brown chests washed their hair in soapy basins, and hoots and hollers from the highlands

floated down from small boys tending their flock of sheep.

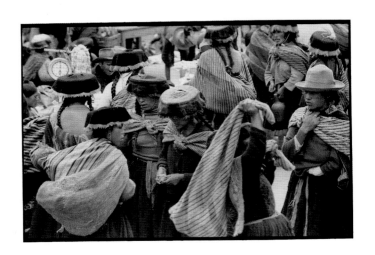

Tia Maria

Ollantaytambo, Peru

There was a woman in town named Tia Maria who was deaf and mute, and who was, in some sense,
the auntie to all, primarily due to her good-naturedness and generosity. I liked her immensely, especially
when she told stories in pantomime. Today she related in great detail how a band of robbers
had overcome her one night, tied her to a chair, and stolen her pig. This story—her narrative of flailing
arms and grunts and mock violence—took the better part of fifteen minutes to tell.

Anesta

Ayassos, Lésvos, Greece

I met Anesta in the groves by a stream. She was feeding olive branches to her three black goats.
"Yasou," I called out to her from the cliff upon which I had been picnicking.
She returned the same greeting and added, "Bravo, bravo." She dismounted her donkey and
bent low to wash her face in the fast running stream.

Gujar Women Leaving Summer Pastures

Kashmir, India

I watched them from behind a clump of boulders. Migratory peoples coming down the
mountains to the lowlands. A young woman in black leading a white donkey upon which sat an old
woman. Perhaps a mother and daughter.

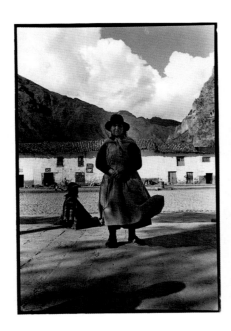
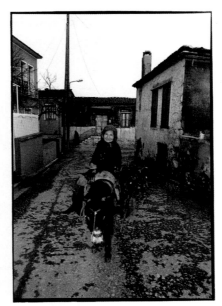
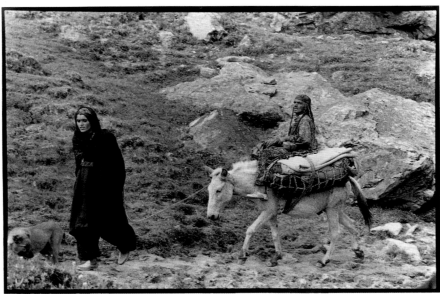

Their two-room hut had hides on the roof. Carcasses of sheep and goats were drying in the sun, and lean dogs slunk about. The family consisted of two grandparents, old-timers with smudgy faces; a father with long hair and a woolly beard; a mother in skins; three sons who rode fast horses across the dusty plain; and five beautiful daughters with long black hair and flashing smiles.

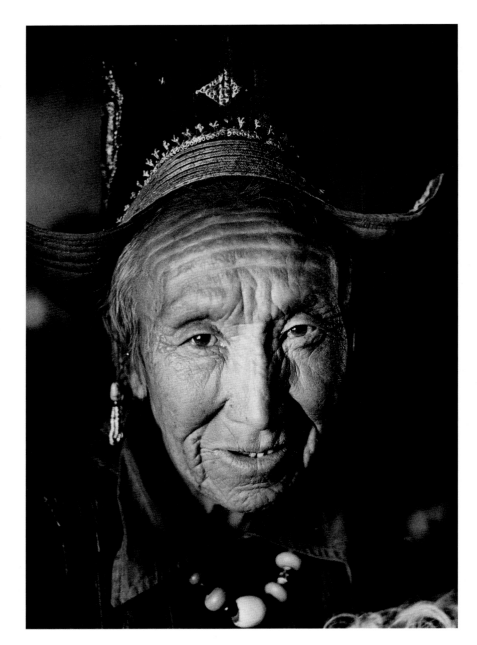

THE GRANDMOTHER

NEAR LEH, LADAKH, INDIA

MARY SIGURDSON, INUIT

WHALE COVE, NORTHWEST TERRITORIES, CANADA

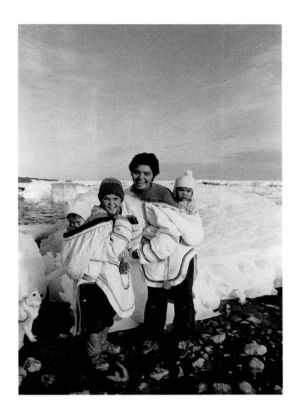

Mary discovered a giant red jellyfish in the nets and took time to observe its pulsing gelatinous matter, intricate veins, and yellow egg sacks. Seven or eight of her family gathered around and made low whispering

sounds as they, too, found beauty in the sea creature.

KATHY MACCLELLAN
OUTER HEBRIDES, SCOTLAND

POCHA AND CARLITOS
OLLANTAYTAMBO, PERU

QUECHUA WOMAN IN CAVE
HUILLOC, OLLANTAYTAMBO, PERU

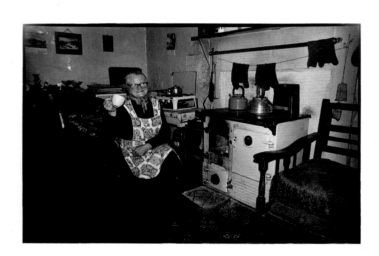

She was the Gaelic singer for all the funerals and weddings in the village. She had learned these songs, as old as the clans themselves, from her mother and grandmother. When I stopped at her small cottage in Rhudgarinish she sang the Twenty-third Psalm for me in Gaelic, and then served me tea and scones and bread and jam as the Atlantic winds and rains pelted the thatched roof.

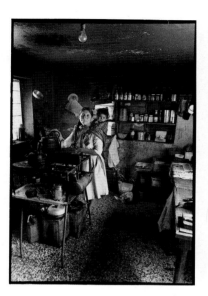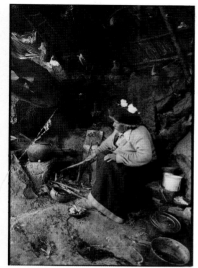

The sun came out and the sky was blue and clear after a terrible thunderstorm. I watched from my balcony as Pocha reached up on her tiptoes, picked a tulip-shaped red blossom from the flowering tree in the dooryard, and handed it to her young son, Carlitos, to play with. Then she moved into the kitchen to begin cooking breakfast.

I made pictures all week in the high mountains. The people seemed to trust me implicitly, and I was even sought out to come to their caves and huts to make portraits. It had not been uncommon for a small child to appear at my pension, knock timidly at the door, and explain in a hushed voice that so-and-so was ill and could I make a family portrait while the person was still alive. Sometimes I traveled on foot as far as ten miles. I did the best I could, coming on the run like a country doctor to make a special portrait. They loved the pictures of themselves (Polaroids) and have so very few, sometimes none at all, to remember a grandfather or grandmother.

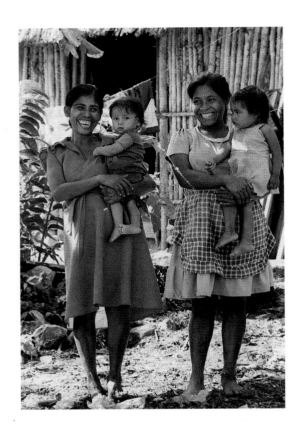

I went to Flores to shop,
catching a ride down
and back on the mail boat.
It was a beautiful ride
along the forested shoreline
where women and children
bathed. There was an
adventurous feeling to
the trip, with men and
women wearing colorful
dress, and children leaning
over and dragging their
hands in the water. I
arrived at the boat launch
late on the way home with
my too-long hair, ripped
jeans, and bare feet
slipping on the wet gun-
wales. As all the seats were
taken I had to squeeze
next to two pretty women.
Everyone in the boat cried
"Eeeeeeeeeiiiiiiiii" all at
once and we all laughed.

I particularly enjoyed my evenings with the four MacCormick siblings. After saying a Gaelic blessing, they would eat. Kate Effie got up from the table every so often to drop another peat into the stove. She was the pivot around which everything turned.

Though nearing 60, she was like a dancer: in four steps to the stove she kicked the cat sideways with a deft slippered foot, bent down to open the firebox, and sighed as she straightened up again and began to stir gravy in a pan with a whirring right hand. Then, weary from her work, she returned to the table.

KATE EFFIE MACCORMICK
OUTER HEBRIDES, SCOTLAND

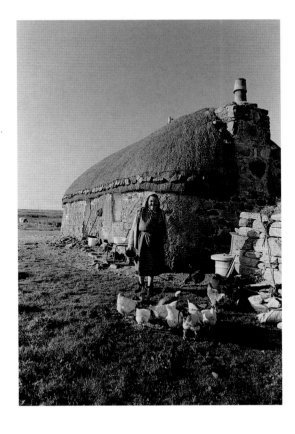

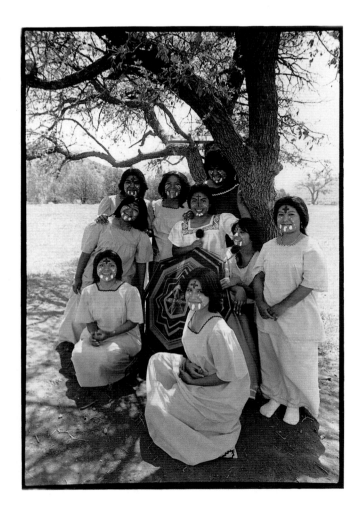

I came upon nine young Pima women at a rest area along the highway. They were en route to a cultural day at a nearby school where they would perform the Basket Dance of their people. They were beautiful and dignified, like quiet doves.

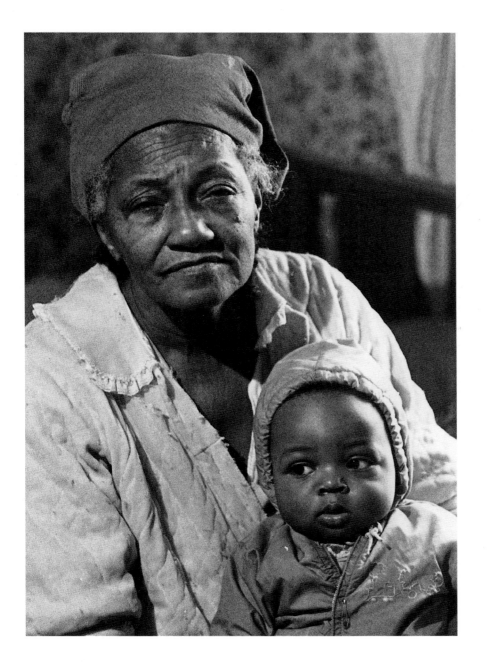

I met an old woman near
Ville Platte as I pulled
into her yard for direc-
tions. She was struggling
with a dull ax trying to
get up some firewood. I
asked if I could help, she
nodded, and I proceeded
to sharpen her ax and
then cut up a quarter of a
cord of limb wood, which
I stacked on her porch.
When I got back in my
car she brought her
grandson out and the lit-
tle boy patted my hand
with his and the
old woman smiled.

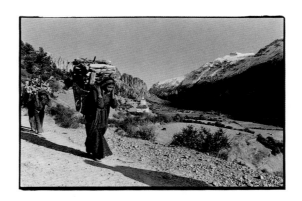

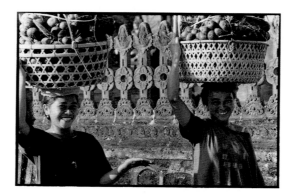

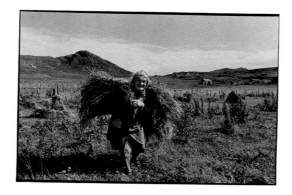

HAULING WOOD HOME
PISANG, NEPAL

OFF TO MARKET
BALI, INDONESIA

KIRSTI MACLEAN
OUTER HEBRIDES, SCOTLAND

Two weeks on the winding mountain trails brought us to the fringe of the high Tibetan Plateau and a village called Pisang. Encircled by the looming Annapurna, Lamjung, and Manaslu Mountains, the village sat in an arctic desert at close to 11,000 feet. Dark-skinned Tibetan women proudly carried loads of one hundred pounds and more, singing as they went.

I walked through the rice paddies near sundown and found two women with baskets of fruit upon their heads. I asked to make a portrait, and they obliged me. Then we parted, I upward on a mountain trail and they toward the village. Every minute or so—as we became smaller and smaller—we would stop and wave to one another. Finally, knowing that the last wave was upon us, I gave an extra special salutation with both arms flailing. And they did the same with great enthusiasm.

In Cleat Cove, where the curved beaches shone white against the dark blue currents of the Gulf Stream, I often went to help an old couple, John and Kirsti MacLean, cut and stack their fall oats. Kirsti, nearing 70, enjoyed teaching me how to bundle the loose oats in the meadow and how to tie them with a few strands of rye grass. Together we trudged with enormous loads upon our backs, laughing the entire way back to the barnyard where John waited for us.

I had two favorite elders in Montouto, both widows who lived close beside each other in rude homes. Francilinde was tall and spare with white hair underneath a black kerchief. She was 88. Maria was shorter and darker and had no teeth. She was 84.

Whenever I appeared on my bicycle for a visit, they emerged from their darkened homes through low doorways to shower me with gifts of apples, grapes, bottles of wine, turnips, and chestnuts. They tried to cram the produce into my camera bag. Somehow it always fit.

There were two young sisters at Shing-O who harvested root crops in the small garden by the stable. I watched them from afar, drawing close when I felt they had accepted my presence. For several afternoons as the sun fell on us, I helped them to pull carrots and smooth-skinned potatoes from the cold ground. The decayed smell of the black composted soil was thick and yeasty in the air. Once I threw a smooth round stone into the collecting basket and pretended that it was a potato. They erupted into laughter and chastised me by slapping my hand.

MARIA AND FRANCILINDE

MONTOUTO, PORTUGAL

SISTERS

SHING-O, LADAKH, INDIA

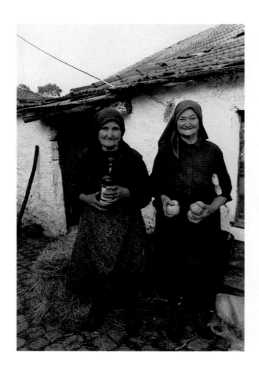
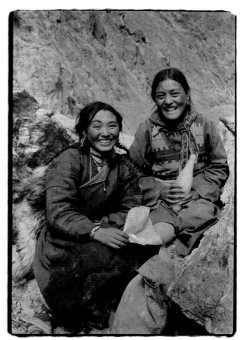

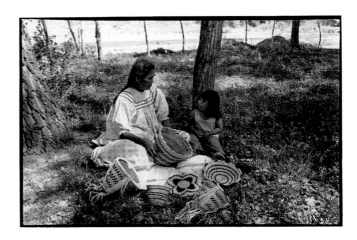

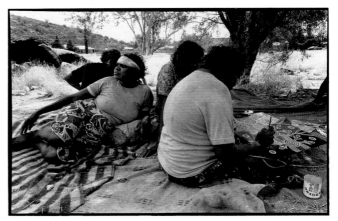

While making baskets Rose told me pieces of her life that touched my heart. She had been born to good parents who always lived in a wicki-up. They never had a car, but used horses. Rose raised her own twelve children, often returning to field work only twelve hours after delivering a baby. She still clung tenaciously to the old Apache ways.

Rose Rooseveld, Whiteriver Apache

Whiteriver, Arizona, United States

Anmatjera and Warlpiri Women

Alice Springs, Australia

At first the Aborigines did not know what to make of a white man coming to see them. But they did allow me

to sit with them around their campfires at night, and on their stone piles in the shade during the day where

women painted the enigmatic designs of their ancestors. These fiery whorls and scrolls perhaps alluded to

dream states, which the Aborigines consider more real than this life.

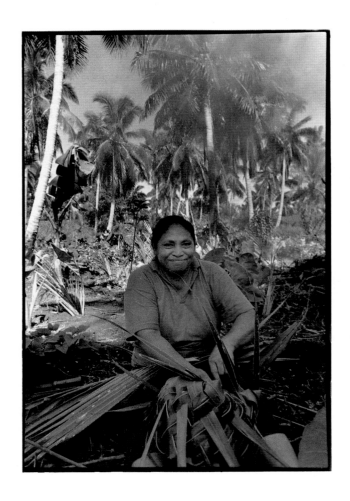

Sissiono took me to the jungle with her to gather the taro from her father's gardens. When she had dug up

ten pounds worth and realized that she had not brought a basket with which to carry the taro home,

Sissiono sat down on the ground and constructed one. I watched amazed as her strong, deft hands pulled

green palm fronds apart and miraculously created a fine, tight-woven basket.

MARY MACINNES, MOTHER OF 15
OUTER HEBRIDES, SCOTLAND

THE AFTERNOON SPINNERS
AYASSOS, LÉSVOS, GREECE

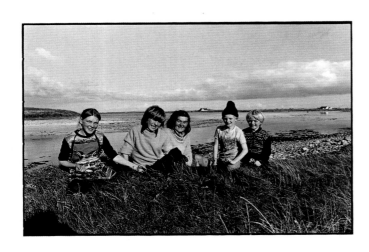

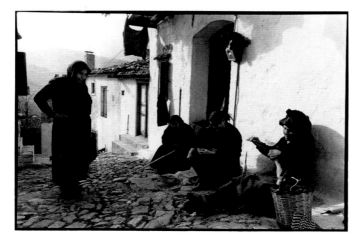

On cold December afternoons I sought refuge from

my cold garret room in the south-facing streets that

caught the sunshine. I liked to gather with four

women there—Vrula, Maria, Panayote, and

Katerina—who would spin wool and talk and even

taught me how to use the drop spindle.

When dusk had covered us and our game of hide-and-

seek was over, we stumbled home toward a window

with a lamp that shone out to the west. Mary had made

fresh scones and the little thatched hut was warm and

smelled of baking dough. She began to feed her chil-

dren, one at a time, with scones, sweet treacle, and cor-

morant soup.

*In Cerrillos, where two women
were watering their corn and
beans in a garden plot, I stopped
and asked if I could fill my
water jugs. I asked Patricia, the
owner of the adobe, how she had
constructed her home. "My hus-
band, Todd, and I built it with
the help of an old Mexican man
who came for two winters and
lived with us. Between the three
of us we handcrafted 14,000
adobe bricks. That old Mexican
man was a Godsend."*

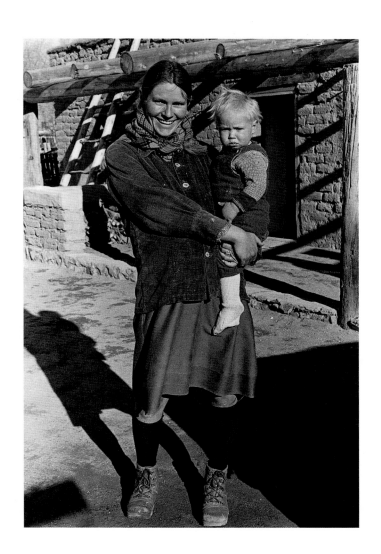

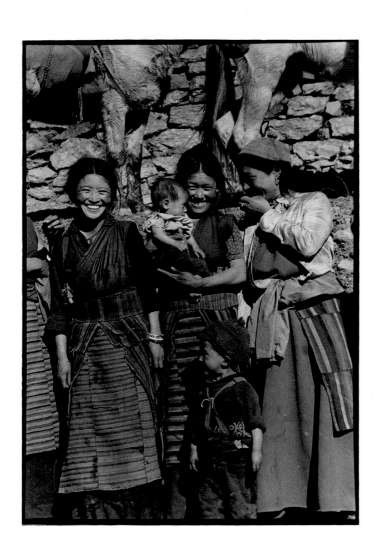

We left Pisang in the morning after a breakfast of barley and fresh yak milk with our family. We climbed high-

er and higher into the Tibetan Plateau, passing from one valley into another and finally arriving in Manang.

Manang, a village of cold and scarcities, was nine days in either direction from the nearest road. There we

encountered a horse fair on the outskirts of town where Tibetan women displayed their proud spirited horses

in hopes of a sale.

SUSAN HENRY

EBENEZER VILLAGE, ANTIGUA

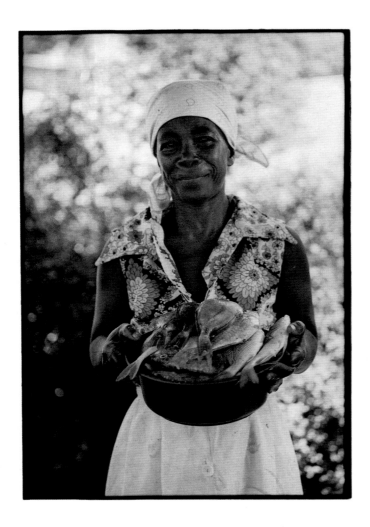

I came upon Susan Henry coming across the sere hill pastures on the ridge between Buckleys and Sweets, up near Bloody Pond. She carried a pan of fresh fish under a cloth and walked barefoot with the grace and agility of a teenager. "Where did you get the fish, Mistress Susan?" I asked.

"Oh, Mistress Jennings saved them for me, and I've been to Buckleys to get them." In my mind's eye I instantly saw her walking the long four miles through the heat and the bush with thorns and stones that cut her feet—so that the children would have a proper dinner tonight.